A DOODLE BOOK

Tümde Waffilar...

28. di. 2017

THE
NEXT
BIG
THING.

Da Vinci, Einstein,
Edison, Newton, Galileo—
so many great thinkers,
innovators, and artists
were doodlers. The simple
act of doodling random,
free-flowing shapes,
squiggles, and words jump-
starts the right side of
your brain, sparking crea-
tivity, and unlocking the
door to new possibilities.
Rethink inspiration.
What's your next big thing?

"Evren bolluk içindedir. Bir kişinin içten isteyeceği her şeyi fazlasıyla veren 'Bereket Boynuzu'dur... Böyle bir evrende kıtlıktan korkmanın gereği yoktur. Sadece senin gibi korku ve şüphe dolu insanlar yoksul olabilir, dünyada bağımlılığı ve yoksulluğu sürekli kılıcı kılabilirler."

Tanrılar Okulu

"Özgür olmayı, her türlü kısıtlamadan uzak bir özgürlüğü düşle. İstediğin her şeyi elde edebilmekten kendini alıkoyan tek kişi sensin! Düşle... Düşle... Hiç durmadan düşle.
"Düş var olan en gerçek şeydir."

Dreamer, Tanrılar Okulu

"Senin dışında gerçekleşen her şey, açığa çıkabilmek için senin içsel onayını almak zorundadır. Bu, hayatında meydana gelen herhangi bir şeyin, senin niyetinin dışsal bir yansıması olduğu anlamına gelir."

Dreamer, Tanrılar Okulu

Get ready! Ideas move very quickly when their time comes. —CAROLYN HEILBURN

Can you hear it?
Your creative
right brain
speaks in subtle
impulses, feelings,
and yearnings.
"I get my ideas,"
said Edison,
"by listening
from within."

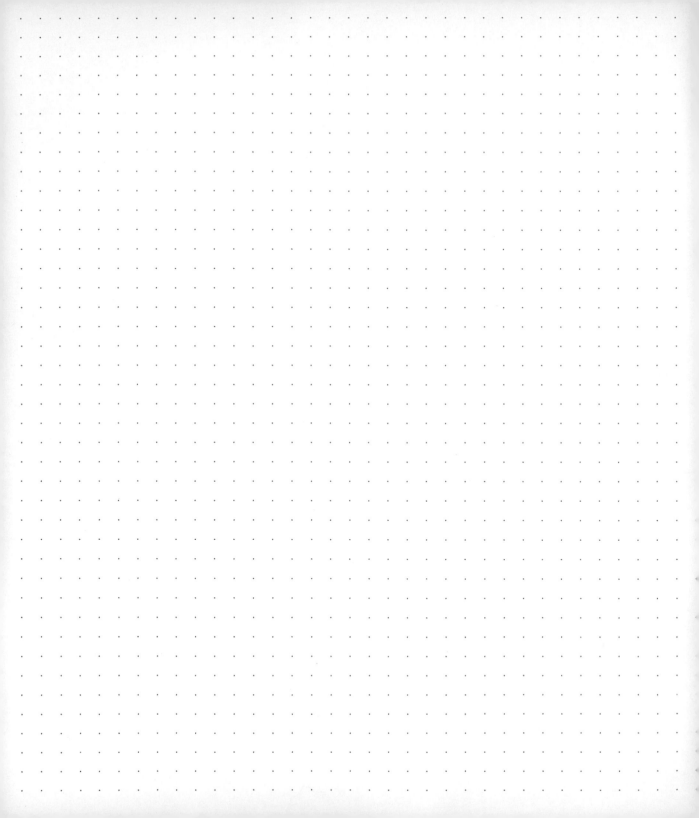

Creativity is inventing, experimenting, growing, taking risks,
breaking rules, making mistakes, and having fun. —MARY LOU COOK

We keep moving forward, opening new doors, and doing new things, because we're curious, and curiosity keeps leading us down new paths. —WALT DISNEY

It first appeared like a crazy idea. It turned out he had a great idea. —J. RICHARD MUNRO

Foolish, unreasonable, outrageous flights of fancy are the forerunners to what finally works. Leonardo da Vinci once dreamed up a 27-yard crossbow that would shoot giant arrows. Foolish? Sure, but that ridiculous crossbow eventually led him to create some of the world's most practical and sophisticated defense systems.

We are called upon to become creators, to make the world new and in that sense to bring something into being which was not there before. —JOHN ELOF BOODIN

Where do you draw the line between possible and impossible? —KOBI YAMADA

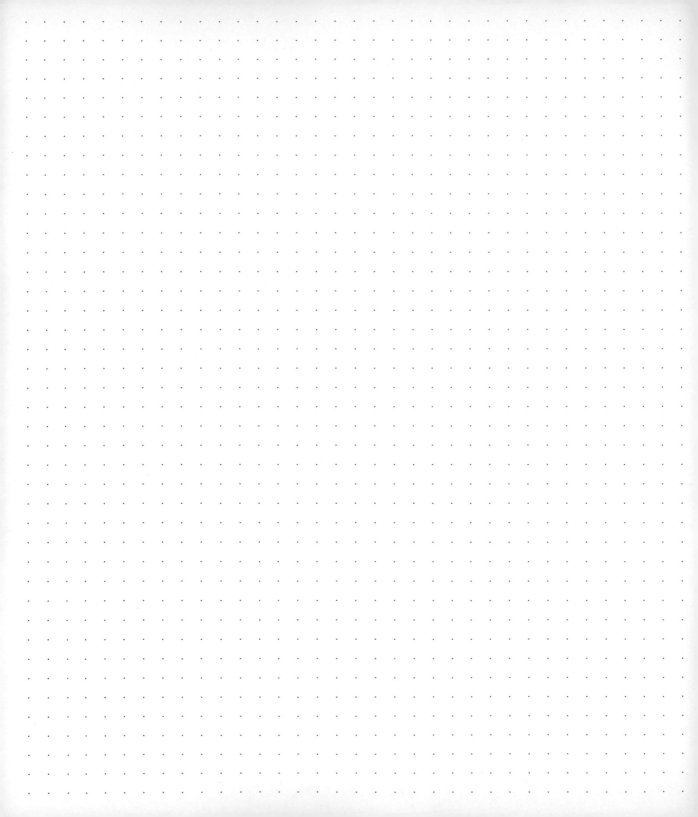

Research is what I'm doing when I don't know what I'm doing. —WERNHER VON BRAUN

Problems are the previous addresses of new ideas. —DAN ZADRA

They trashed the rules and found new ways to win. —MARK ROMAN

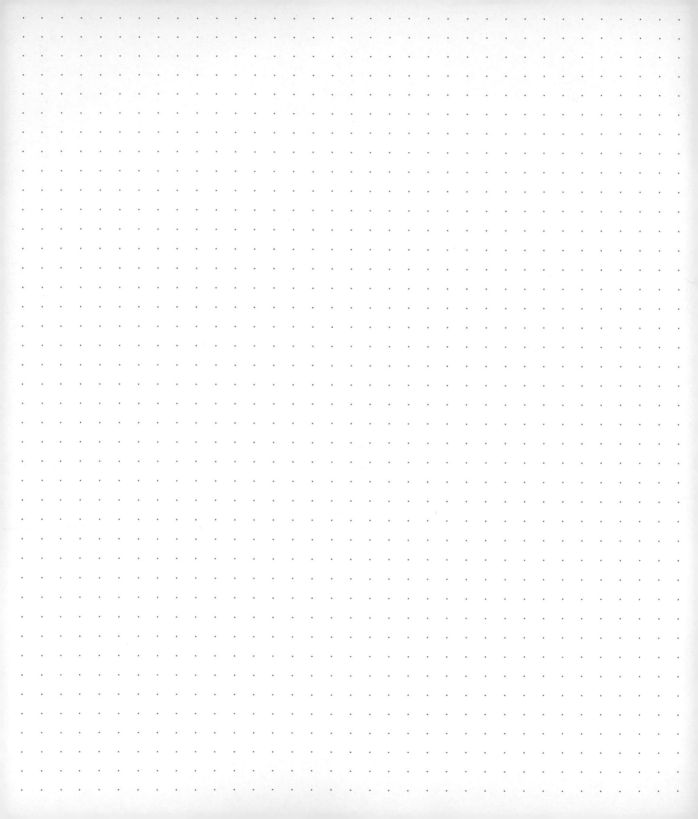

One day Pablo Picasso noticed an old bicycle seat and handlebars. He welded them together to form a bull's head and horns. After he displayed the piece in a show, he wrote to a friend, "Suppose that one day my head of a bull were to be thrown on a junk heap. Maybe a little boy would come along and notice it and say to himself, 'Now there's something I could use as a handle-bar for my bike.' If that ever happens, we will have brought about a double metamorphosis."

You have a creative contribution to make. Your life, and mine, will be better if you do. —MICHAEL TOMS

The purpose of music and maybe even the purpose of life is to connect with people and create. —ERIC MOE

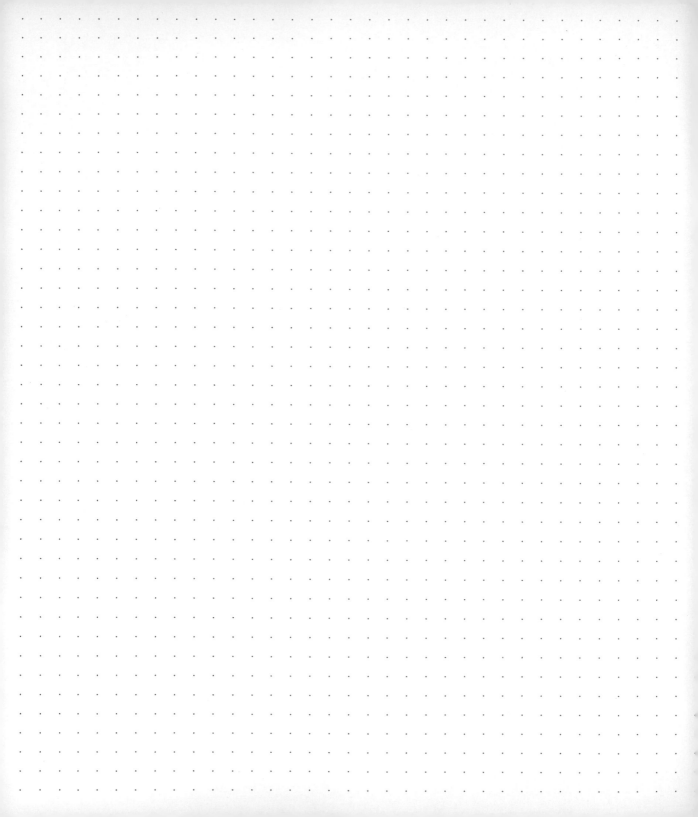

The difficulty lies not so much in developing new ideas as in escaping from old ones. —JOHN MAYNARD KEYNES

...you must be willing to do a somersault into the inconceivable... —WAYNE DYER

Art washes away from the soul the dust of everyday life. —PABLO PICASSO

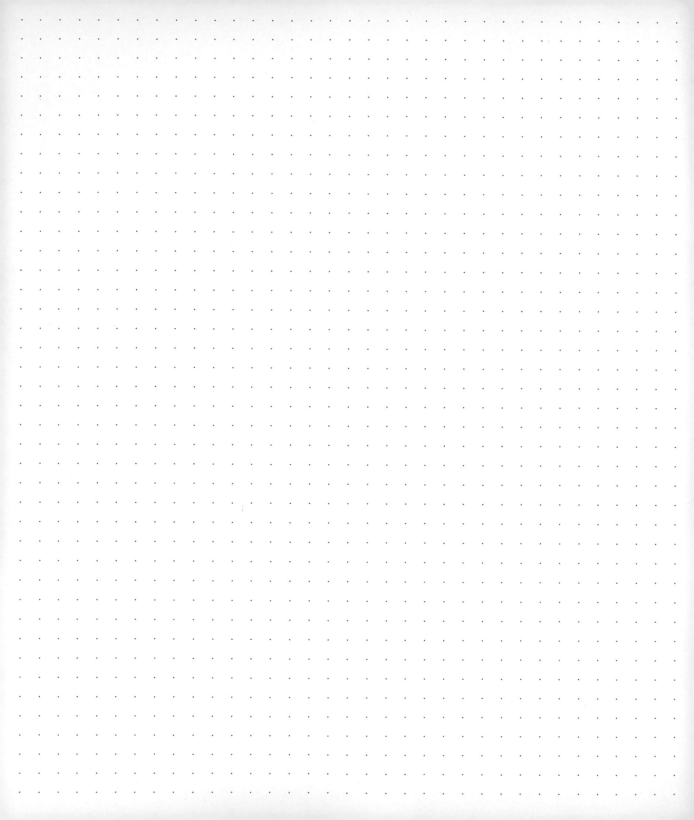

Thousands of perceptions, hunches, ideas and intuitions race through our brains every day.
Some are pure genius. Give them the red light for at least long enough to write them down.

—RALPH FORD

Many great discoveries or ideas were the result of someone looking for one thing and finding another. Columbus was looking for India when he stumbled on North America. Radium, Silly Putty, penicillin, Post-it Notes, and thousands of other so-called brilliant discoveries were actually serendipitous accidents or by-products. Don't be so focused on finding or creating one thing that you overlook something of equal or greater value right in front of you.

Your dreams are not meant to put you to sleep, but to alert and arouse you to your immense possibilities. —DAVID PHILLIPS

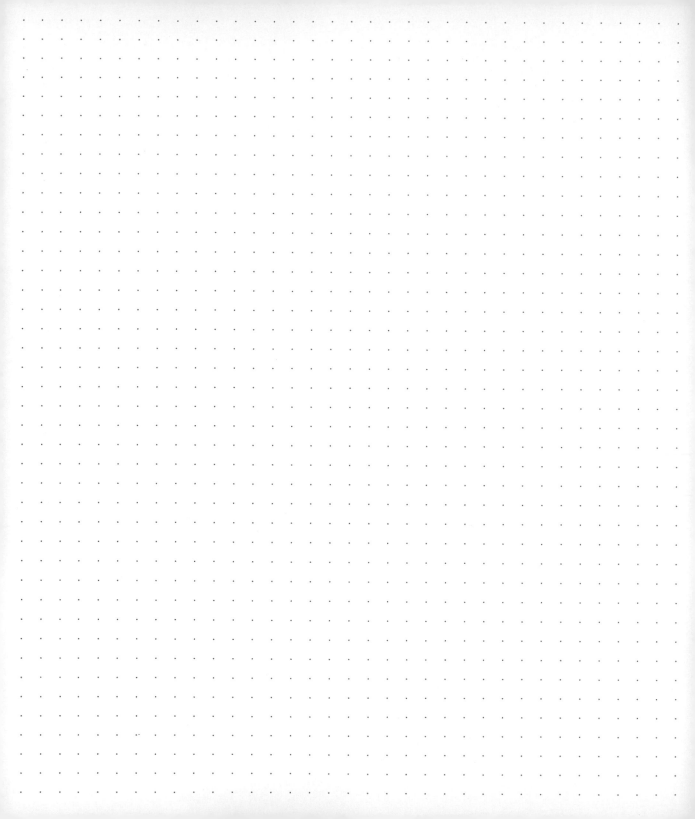

The law of flying was not discovered by the contemplation of things staying on the ground. —WAYNE DYER

By artist I mean of course everyone who has tried to create something which was not here before him, with no other tools and material then the uncommerciable ones of the human spirit.... —WILLIAM FAULKNER

A proven way to trigger subconscious creativity is to continually whisper "what if..." and then write down any random impressions that jump into your mind. One day Gutenberg asked himself, "What if I took a bunch of little coin punches and put them under the force of one big wine press? Wouldn't the force of the wine press cause the various coin punches to leave impressions on the paper?" The answer, of course, was yes— and the printing press was created.

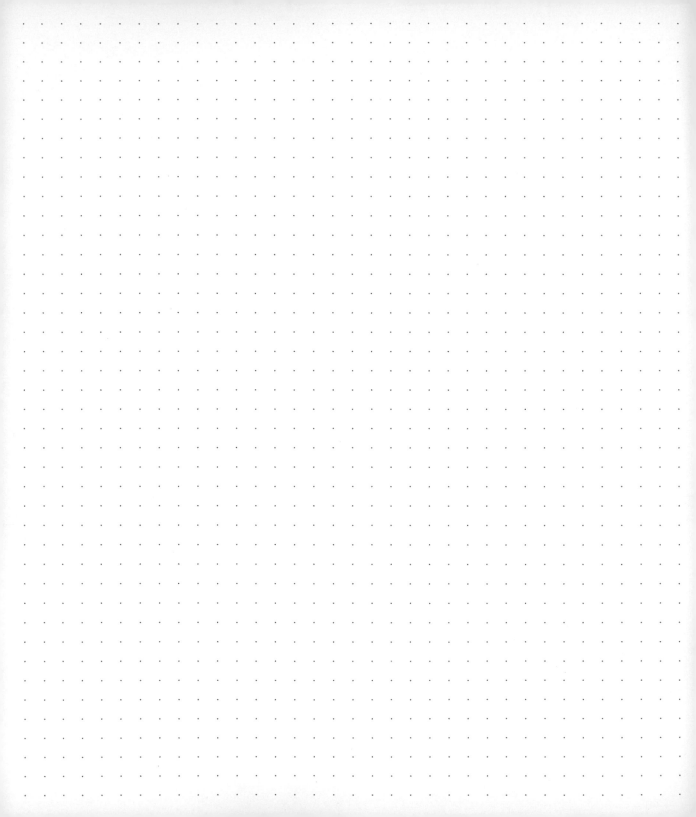

The urge for good design is the same as the urge to go on living. The assumption is that somewhere, hidden, is a better way of doing things. —HARRY BERTOIA

Some men see things as they are and ask why. Others dream things that never were and ask why not. —GEORGE BERNARD SHAW

One eye sees, the other feels. —PAUL KLEE

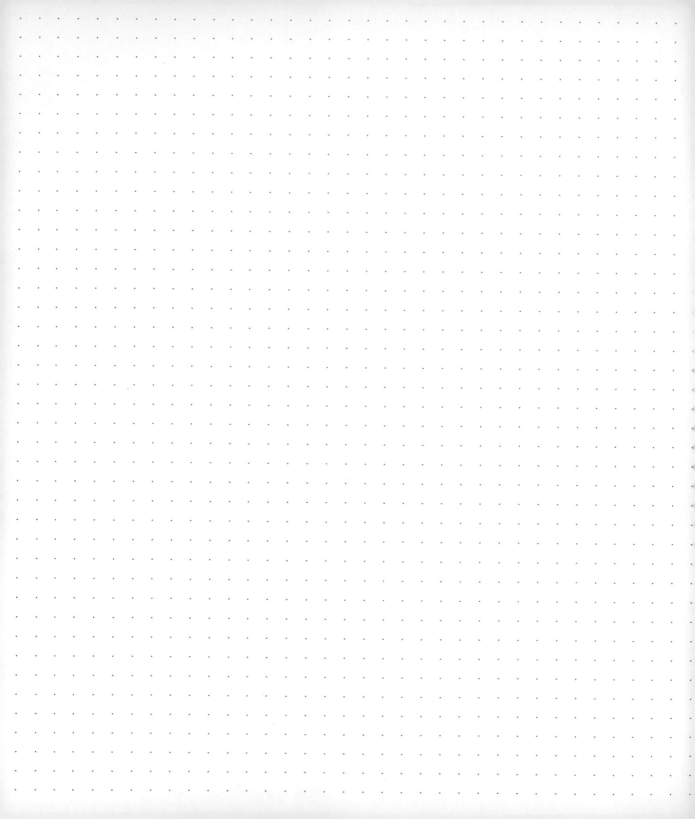

Imagination continually frustrates tradition; that is its function. —JOHN PFEIFFER

For ages, the Earth was thought to be the center of the solar system, simply because Claudius Ptolemy said so. Prior to Columbus, everyone thought the world was flat, and that a ship would sail off the edge if it went too far. For hundreds of years there was no such thing as left shoes and right shoes—just shoes. Innovations occur whenever someone like you challenges the way things have always been done.

The prize goes to the person who sees the future the quickest. —WILLIAM STIRITZ

I call intuition cosmic fishing. You feel a nibble,
then you've got to hook the fish. —R.BUCKMINSTER FULLER

We all know our ideas can be crazy, but are they crazy enough? —KOBI YAMADA

Great ideas...come into the world as gently as doves...if we listen attentively, we shall hear amid the uproar...a faint flutter of wings, the gentle stirring of life and hope. —ALBERT CAMUS

One of the most effective ways to come up with something new is by looking at something old and allowing it to inspire something similar but different. The process is called "direct analogy." Analogous means "similar to." The camera was invented by studying something similar—the human eye. Roll-on deodorant was inspired by the ball-point pen. And Velcro (a multi-billion dollar product) was inspired by mimicking the sticky cocklebur.

Always listen to experts. They'll tell you what
can't be done and why. Then do it. —ROBERT HEINLEIN

See things as you would have them be instead of as they are. —ROBERT COLLIER

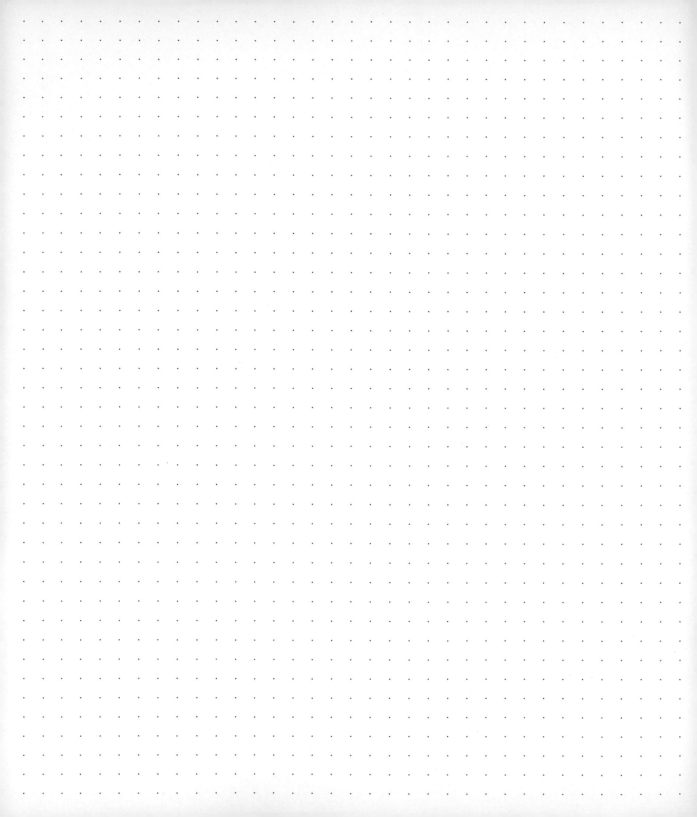

Imagination is everything. It is the preview of life's coming attractions. —ALBERT EINSTEIN

Beware when the great God lets loose a thinker on this planet. —RALPH WALDO EMERSON

Ideas first.
Practicality later.
Are your ideas
too expensive?
Too wild? Too
impractical?
Too complicated?
Great, you're on
the right track!
For now, forget the
problems and just
let the ideas flow.
Remember: You can
always come back
later and figure
out how to build
practicality
into your ideas.

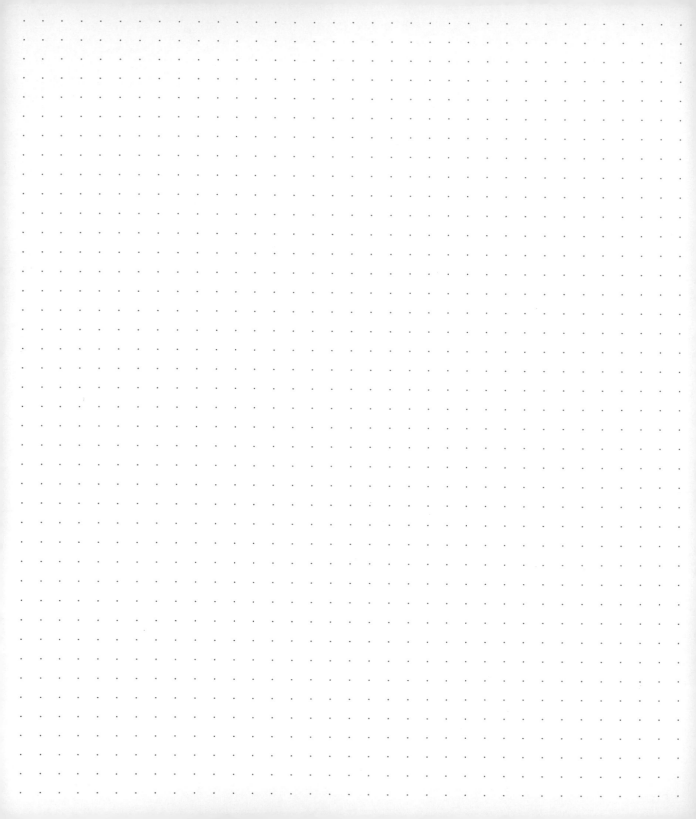

Never turn your back on your own ideas. —DAN ZADRA

There is a way to do it better—find it. —THOMAS EDISON

Getting into trouble is our genius and glory.... —JOHN PFEIFFER

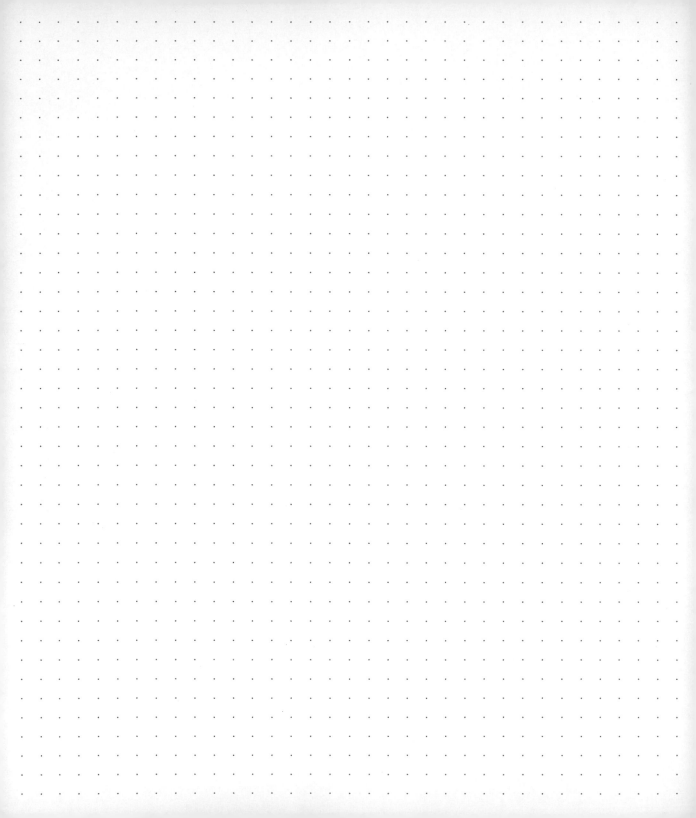

The next time your mind wanders, follow it around for a while. —JESSICA MASTERSON

Make visible what, without you, might perhaps have never been seen. —ROBERT BRESSON

When you become quiet, it just dawns on you. —THOMAS EDISON

Nothing in life is more exciting and rewarding than the sudden flash of insight that leaves you a changed person. —ARTHUR GORDON

Conception is a
matter of connection.
Your brain is a vast
database of 30 bil-
lion neurons, each
capable of storing up
to a million bits of
information. Moments
of insight occur
by stimulating new
connections between
your stored data or
experiences. Connect
the game of golf with
a Frisbee, and you
have Frisbee golf.
By adding fresh
information, you
increase the number
of fresh connections
you can make.

To stay ahead, you must always have your next idea waiting in the wings. —ROSABETH MOSS KANTER

Everyone is a genius at least once a year. The real geniuses simply try to have their bright ideas closer together. —GEORGE C. LICHTENBERG

When you have exhausted all possibilities, remember this—you haven't. —THOMAS EDISON

A time-honored slogan of the 3M innovation team is, "You have to kiss a lot of frogs to find a prince." A ConAgra executive calculated that 40 million ideas were processed to generate 40,000 actual products. Question: Are you willing to generate 1,000 dead-end ideas to arrive at one great one? If so, remember that brainstorming can easily yield 50-250 ideas in an hour. Brainstorm one hour each day for a week, as 3M product teams do, and you might have a great idea by Friday.

Stung by the splendor of a sudden thought.

—ROBERT BROWNING

Drawing is the art of taking a line for a walk. —PAUL KLEE

Give something a name, and it will happen. —UNKNOWN

Now and then, we all experience one of those blinding flashes of the obvious—the big "Aha!" that springs fully-formed from our creative subconscious. But some of your best ideas and inspirations will first emerge looking more like lumpy, homely, half-baked loaves of bread. Respect those ideas. Don't toss them away—write them down. Continue to bake, butter, and better them.

When I haven't any blue I use red. —PABLO PICASSO

What writing, like Zen practice, does is bring you back to the natural state of mind, the wilderness of your mind where there are no refined rows of gladiolas. —NATALIE GOLDBERG

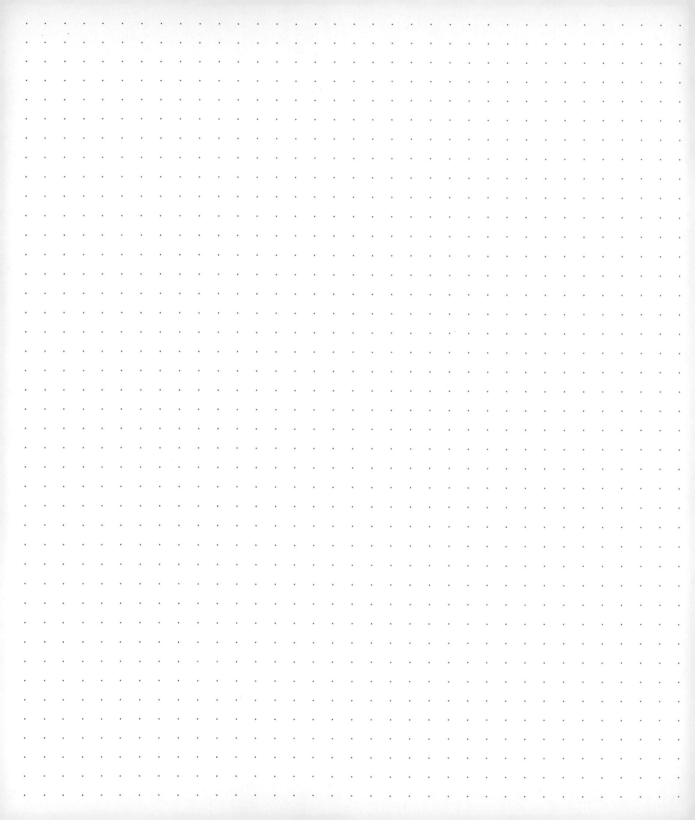

British author
Beatrix Potter
said she felt
lucky that she
didn't attend
school because
all that educa-
tion might have
interfered with
her originality.
Stop guessing
what's in the
teacher's head or
your boss's head.
What the world
really needs to
know right now
is what's in
your head.

When you respond to something because it's so beautiful, you're really looking at the soul of the person who made it. —ALICE WALKER

There are two worlds: the world that we can measure with line and rule, and the world we feel with our hearts and imaginations. —LEIGH HUNT

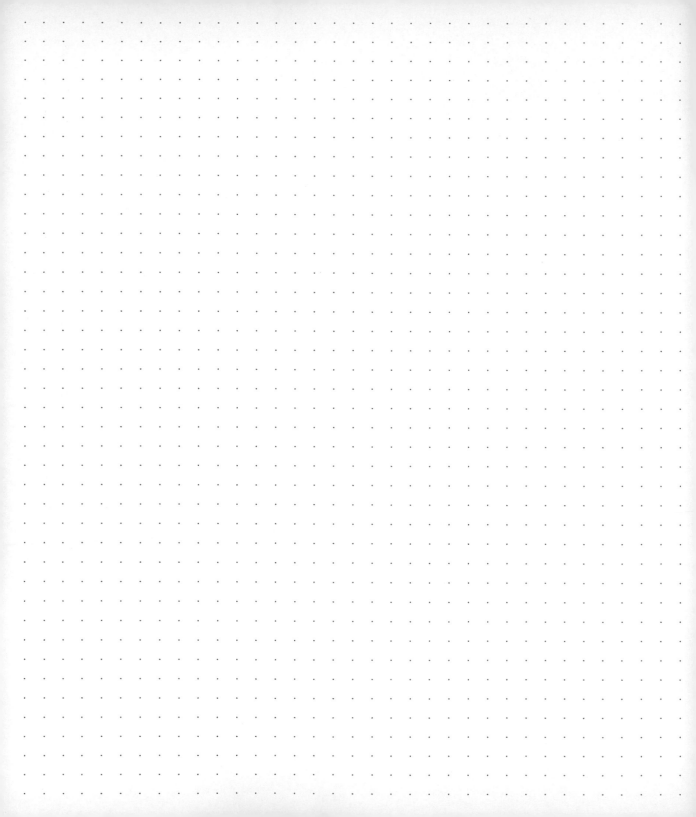

...don't just create what the market needs or wants. Create what it would love. —HARRY BECKWITH

According to Timothy Gallwey (*The Inner Game of Tennis*), great music, art, poetry, or sudden "aha's" usually arise when the non-stop-talking left side of the brain has been turned off or at least quieted. Meditation is one way to do that. Chanting is another way. But simply humming or singing can also quiet the jabbering left brain.

Success is often just an idea away. —FRANK TYGER

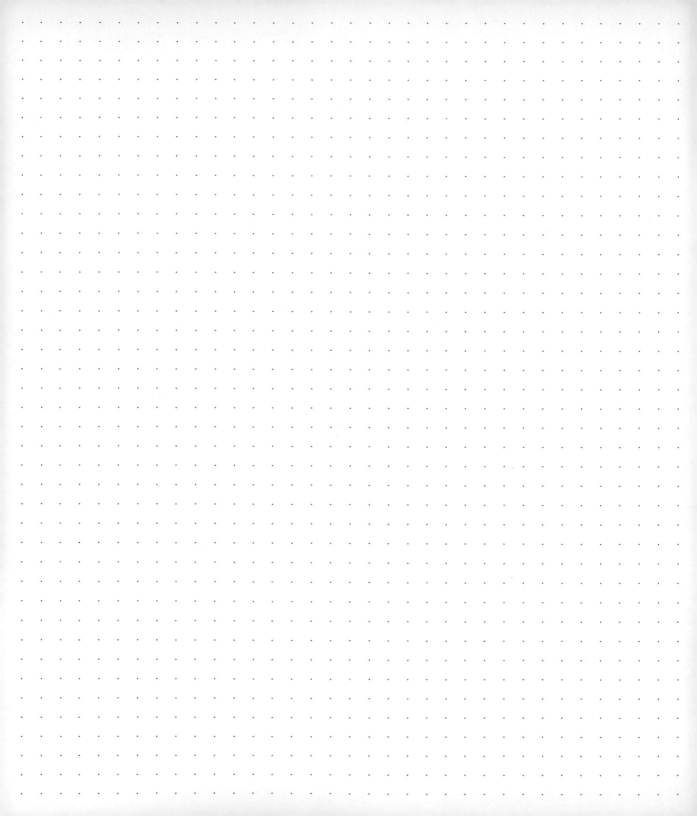

I have forced myself to begin writing when I've been utterly exhausted, when I've felt my soul as thin as a playing card...and somehow the activity of writing changes everything.

—JOYCE CAROL OATES

We need to make the world safe for creativity and intuition, for it's creativity and intuition that will make the world safe for us. —EDGAR MITCHEL

Most creative ideas
come from taking
something that
already exists and
thinking forward
to improve it.
To come up with
something truly
original, try doing
the opposite. Just
think of something
that everyone agrees
would be wonderful
if it were only
possible, and then
work backwards to
imagine what it
might look, sound,
or operate like.

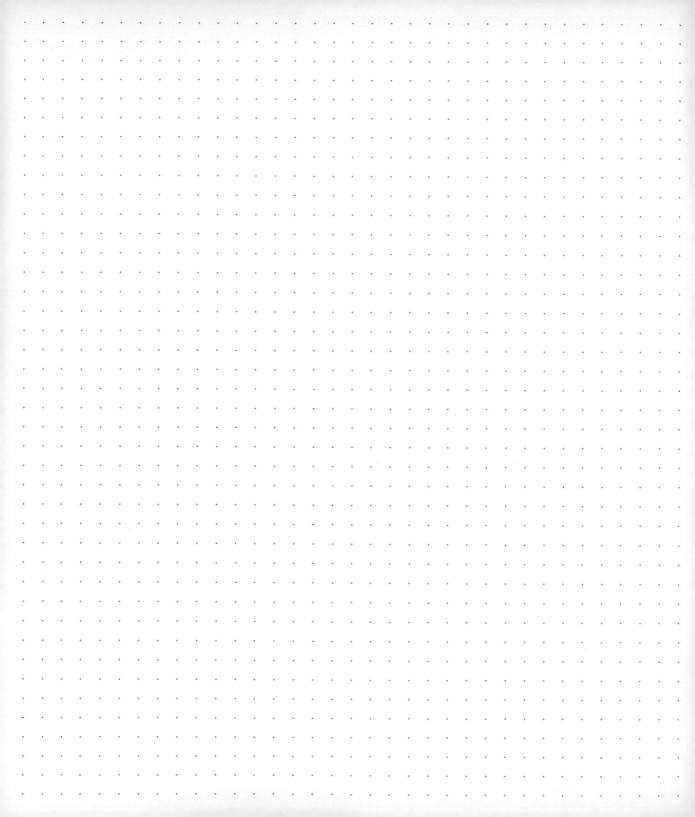

Don't be confined by reality or precedent. Think about what could be accomplished if there were no boundaries. —JAMES FANTUS

If you do not express your own original ideas, if you do not listen to your own being, you will have betrayed yourself. —ROLLO MAY

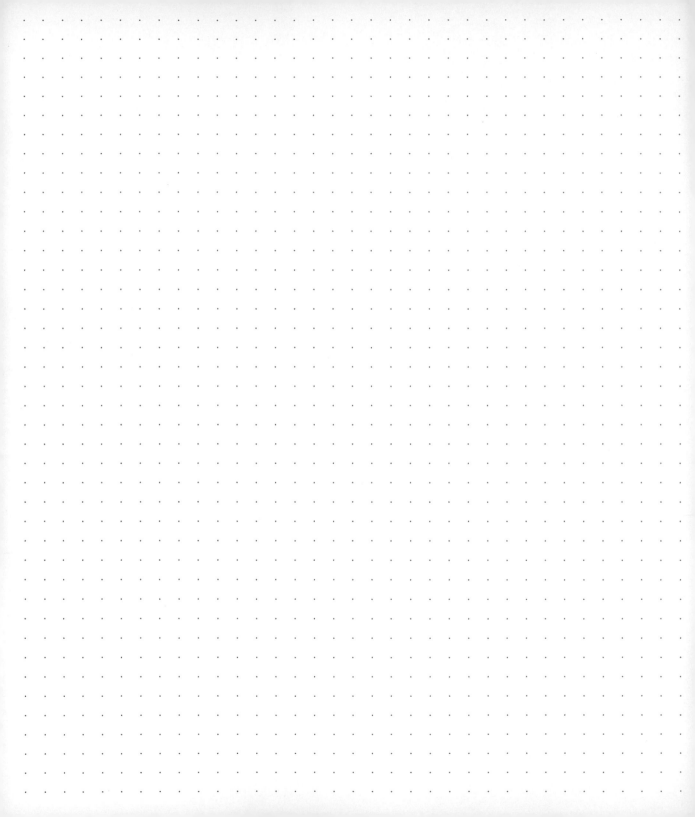

You're the best antidote for all the unoriginal thinking that's going on around you. —ROB BREZSNY

Sometimes we need to prod or provoke our minds out of their usual grooves. Creativity consultant Edward de Bono provokes community leaders into new ideas by using quirky exaggeration. Here's an example. Problem: New York City can't afford more police patrolmen. De Bono's Exaggeration: What if police had six eyes instead of just two? Idea: Maybe individual citizens could be extra eyes for police. Final Idea: The popular Neighborhood Watch Program, which has now been modelled all across the nation.

A single idea can transform a life, a business, a family, a nation, a world. —DAN ZADRA

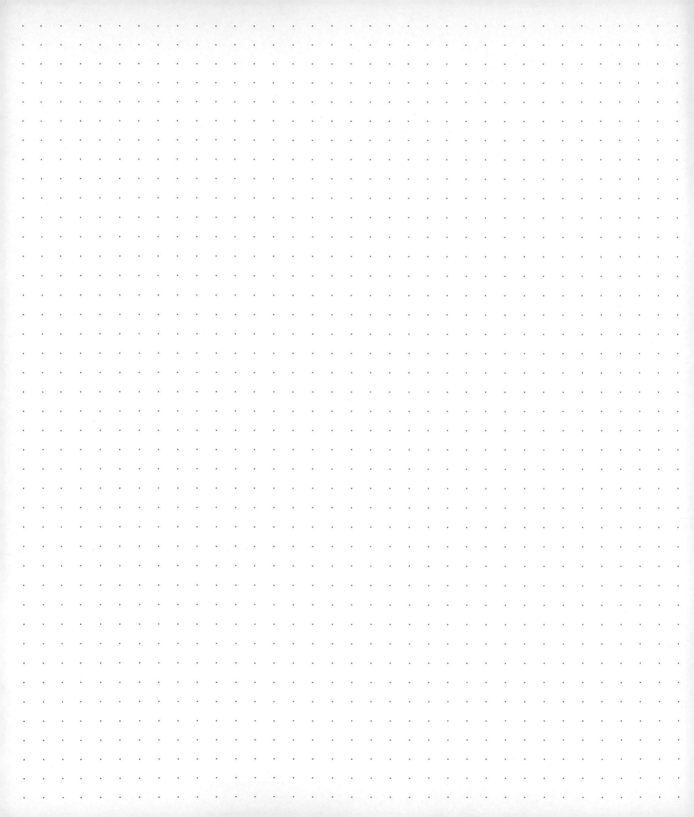

Lack of money is no obstacle. Lack of an idea is an obstacle. —KEN HAKUTA

Where there is an open mind there will always be a frontier. —CHARLES F. KETTERING

The most damaging words in the English language are,
"It's always been done that way." —ADMIRAL GRACE HOPPER

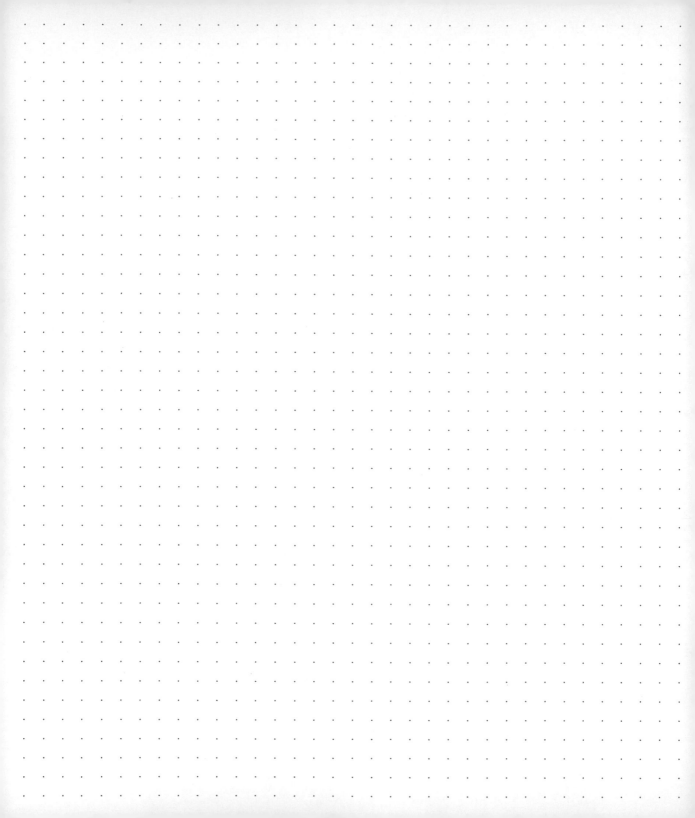

The primitive wheel, lever, and pulley all built on each other to eventually spawn the automobile. That's how it works. Others invented the plough, but John Deere made it out of steel. Others conceived overnight shipping, but Fred Smith made it practical by creating the hub and spoke delivery concept. As Howard Newton puts it, "People don't give a hoot about who made the original whatzit. They want to know who makes the best one."

...I want to stay as close to the edge as I can without going over. Out on the edge you see all kinds of things you can't see from the center. —KURT VONNEGUT

I feel there are two people inside of me—me and my intuition. If I go against her, she'll screw me every time, and if I follow her, we get along quite nicely. —KIM BASINGER

It could be that there's only one word and it's all we need. It's here in this pencil. Every pencil in the world is like this. —W.S. MERWIN

Somewhere on this planet, someone has a solution to each of the world's problems.
It might be one of us. With your help, we can build a more hopeful world. —MARIANNE LARNED

Big ideas attract
big support. A team
of educators failed
to raise $200,000
for a state-wide
learning center
but found immediate
funding for a far
more exciting and
visionary multi-
million dollar
orbiting satellite
that would beam
news and informa-
tion to every school
in the nation.

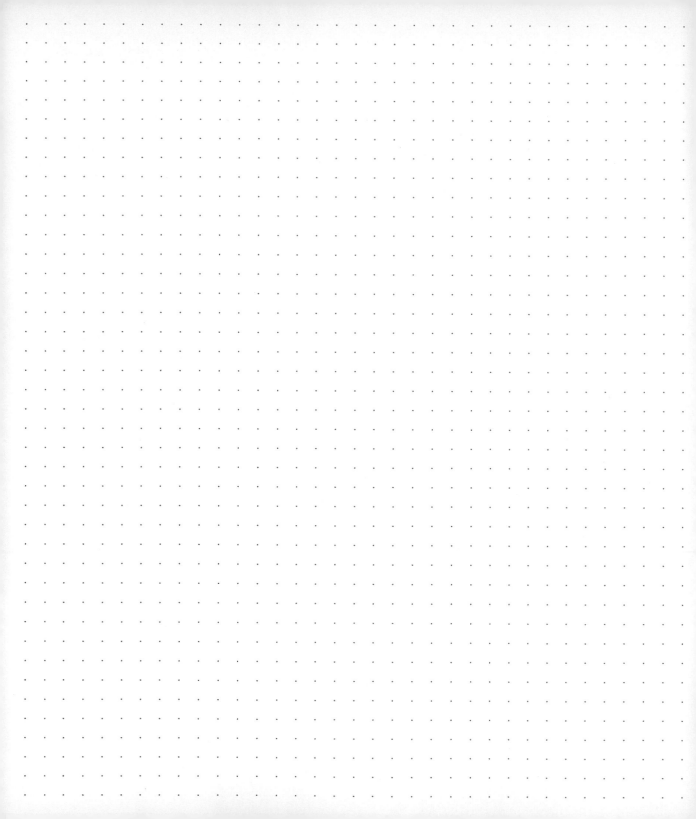

Creativity is allowing yourself to make mistakes. Art is knowing which ones to keep. —SCOTT ADAMS

No, no, you're not thinking; you're just being logical. —NIELS BOHR

Lots of positive things have been created by thinking negative. Someone comes along and asks, "What could I or my company destroy, counteract, eliminate, combat, neutralize or undo?" That's how words such as algesia, biotic, histamine, infectant, odorant and cola became analgesic, antibiotic, antihistamine, disinfectant, deodorant and Un-Cola. Today, try thinking, "Anti-something...unsomething...dis-something...or de-something" and see where it takes you.

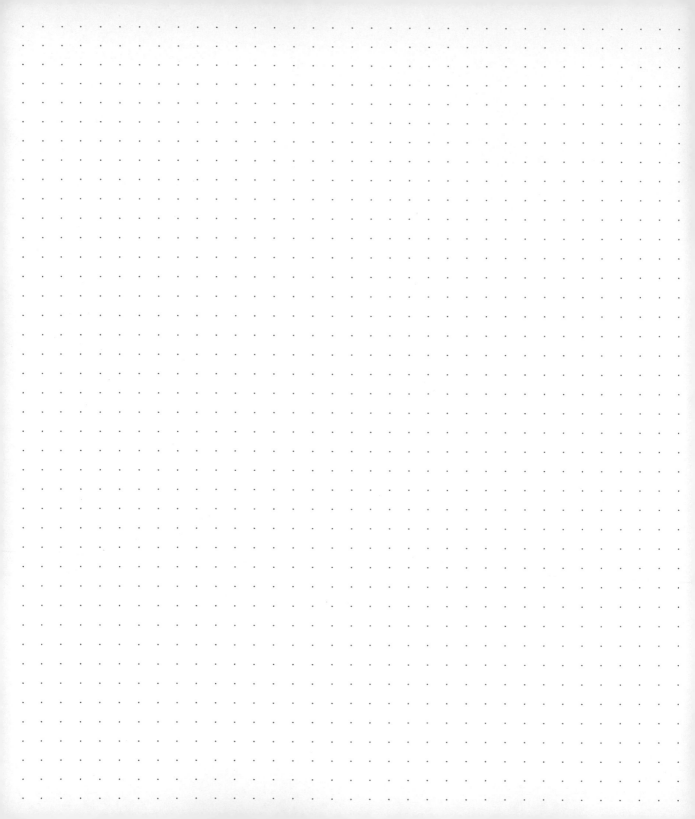

Life is like an ever-shifting kaleidoscope—
a slight change, and all patterns alter. —SHARON SALZBERG

The mind I love
must have wild
places, a tangled
orchard where
dark damsons
drop in the
heavy grass, an
overgrown little
wood, the chance
of a snake or
two, a pool that
nobody's fath-
omed the depth
of, and paths
threaded with
flowers planted
by the mind.

—KATHERINE MANSFIELD

Once a new idea springs into existence, it cannot be unthought.
There is a sense of immortality in a new idea. —EDWARD DE BONO

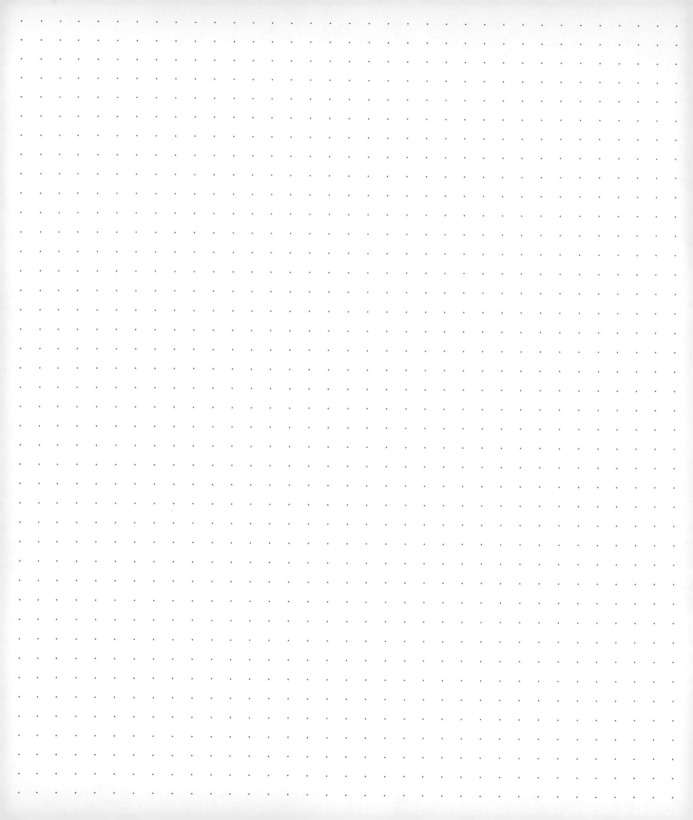

Bernard Baruch believed that the ability to succinctly express an idea is virtually as important as the idea itself. J. Conrad Levinson believed that ideas move faster if the core concept can be encapsulated in seven to ten words. David Belasco urged people to try to fit their entire idea on the back of a business card.

Once in a museum [painter Pierre] Bonnard persuaded his friend Vuillard to distract an attendant while he approached his old painting, slipped from his pocket a tiny box of paints and a brush the size of a toothpick, and added to one of his consecrated canvases minute touches that set his mind at rest.

—ANNETTE VAILLANT

If no one has been annoyed for some time by what he sees to be your irresponsibility, you should consider whether you are holding your imagination too much in check. —EDMUND PHELPS

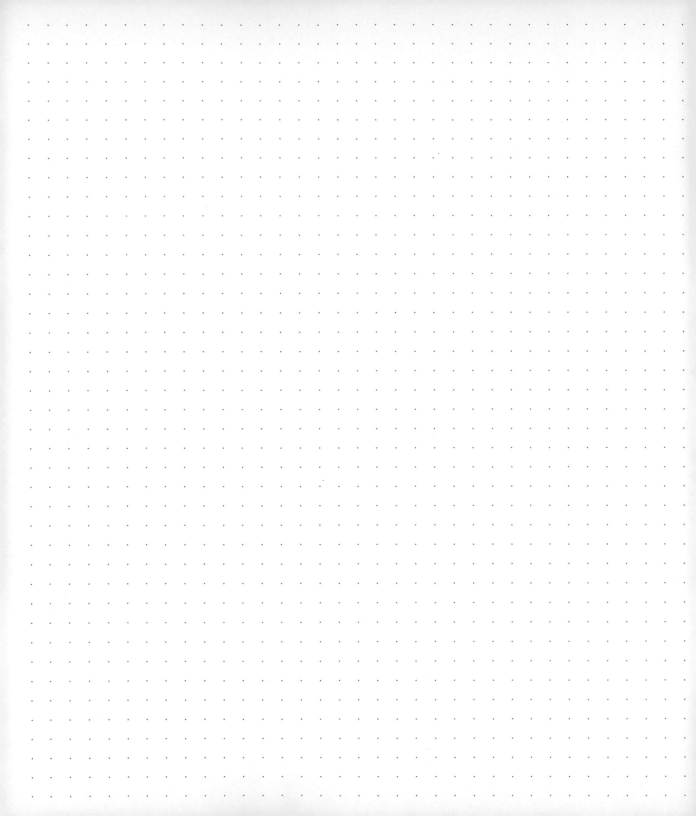

Art flourishes where there is a sense of adventure. —ALFRED NORTH WHITEHEAD

As long as you can start, you are all right. The juice will come. —ERNEST HEMINGWAY

Everything is always impossible before it works. —DR. ALBERT SCHWEITZER

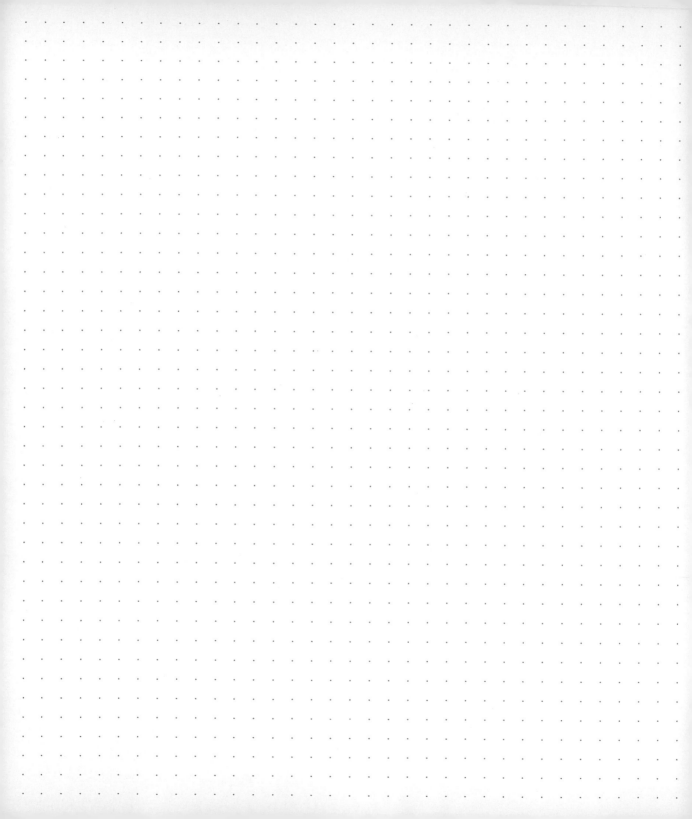

We have a problem. "Congratulations." But it's a tough problem. "Then double congratulations."

—W. CLEMENT STONE

If you've lost focus, just sit down and be still. Take the idea and rock it to and fro. Keep some of it and throw some away, and it will renew itself. —CLARISSA PINKOLA ESTES

The imagination needs moodling—long, inefficient, happy idling, dawdling, and puttering. —BRENDA UELAND

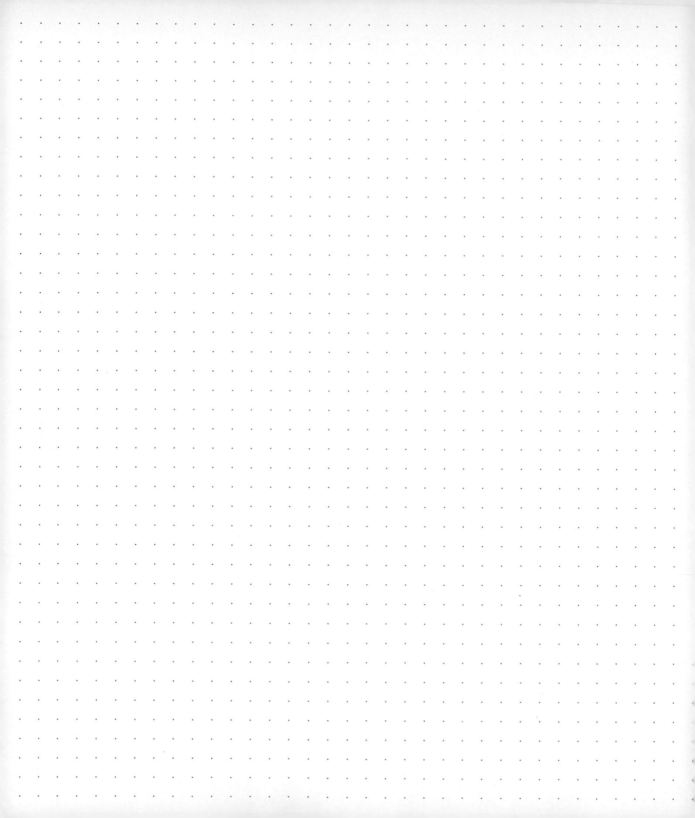

Throughout history, great thinkers have been alert to certain times of the day when ideas or creativity come easier. Bach, for example, liked to lay in bed after a nap and compose music while still half asleep. Creativity consultant Charles "Chic" Thompson has identified today's most "idea-friendly" times to keep a pad and pen handy. His top five are: during a boring meeting, while falling asleep or waking up, while commuting to work, while showering, while in the bathroom.

"Being in the flow" is definitely something worth striving for. I know when I'm there. I'm tapped into something that is far beyond my ability. —ALETA PIPPIN

It seems to me that those songs that have been any good, I have nothing much to do with the writing of them. The words have just crawled down my sleeve and come out on the page. —JOAN BAEZ

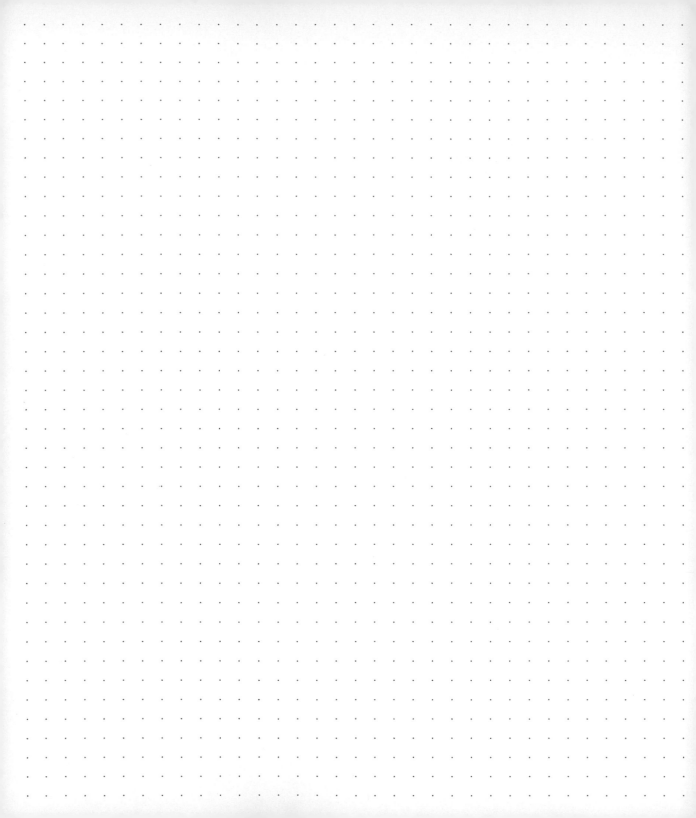

There's an alternative. There's always a third way, and it's not a combination of the other two ways. It's a different way. —DAVID CARRADINE

RULES FOR BRAINSTORMING: Stay looose, have fun, keep an open mind, record everything, piggyback on ideas, shoot for quantity first and quality later.

What we have done
has barely scratched
the surface. It
turns out that
there is, in fact,
unlimited juice in
that lemon. The
fact is, this is
not about squeezing
anything at all: It
is about tapping an
ocean of creativity,
passion, and energy
that, as far as we can
see, has no bottom
and no shores.
—JACK WELCH

In my dream, the angel shrugged and said, If we fail this time, it will be a failure of imagination and then she placed the world gently in the palm of my hand. —BRIAN ANDREAS

COMPENDIUM™
INCORPORATED

live inspired.

With special thanks to the
entire Compendium family.

Written and Compiled by: Dan Zadra
Designed by: Steve Potter
Editted by: Jennifer Pletsch
Creative Direction by: Sarah Forster